THE FLIGHT OF THE M

Art: Bhajju Shyam Text: Gita Wolf and Sirish Rao

TARA BOOKS

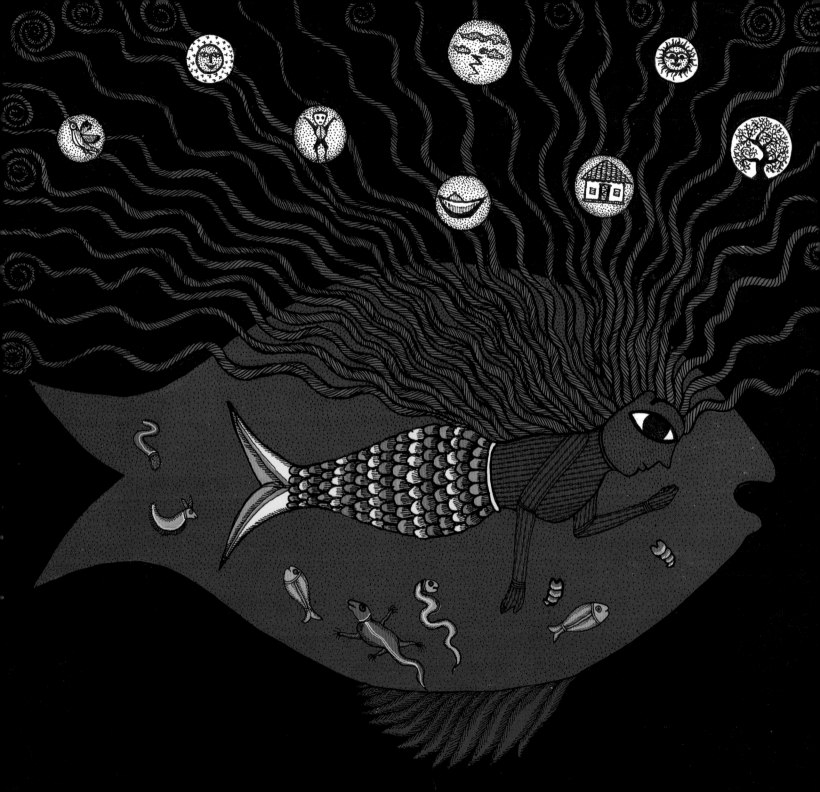

MERMAIDS LIVE IN THE DEEP, A PLACE WHERE DAY AND NIGHT ARE THE SAME THING, FILLED WITH CREATURES SO FANTASTIC THAT IT CAN HARDLY BE BELIEVED THAT THEY EXIST.

MERMAIDS ARE NEITHER FISH, NOR HUMAN. OR THEY ARE BOTH – FISH AND HUMAN. IT IS HARD FOR US TO KNOW WHAT THEY ARE AND WHERE THEY BELONG. AND THIS WAS WHAT A CERTAIN YOUNG MERMAID OFTEN FOUND HERSELF PONDERING.

The mermaid's mother died when she was young, and she and her five older sisters had been brought up by their grandmother.

"You dream too much, my dear!" the mermaid's grandmother often said to her "Come, you need to live in the real world."

The mermaid tried to listen, but before long, she was lying on the sea bed, letting her thoughts bubble to the world that existed on the surface far above.

Each of the six mermaid sisters had their own small sea-garden of coral, seaweed, shells and pebbles.

But here too, the youngest mermaid could not help being different. Her garden was the most unusual, like nothing any mermaid had ever made. In its centre stood a statue of a man, torn loose from some shipwreck.

As is the way on the sea floor, when each of the older sisters turned eighteen and came of age, they were allowed to swim up to the waves and spend the day on the surface of the sea, looking at the world above.

When they returned, their stories made the mermaid long for the day when she could get a glimpse of that world for herself.

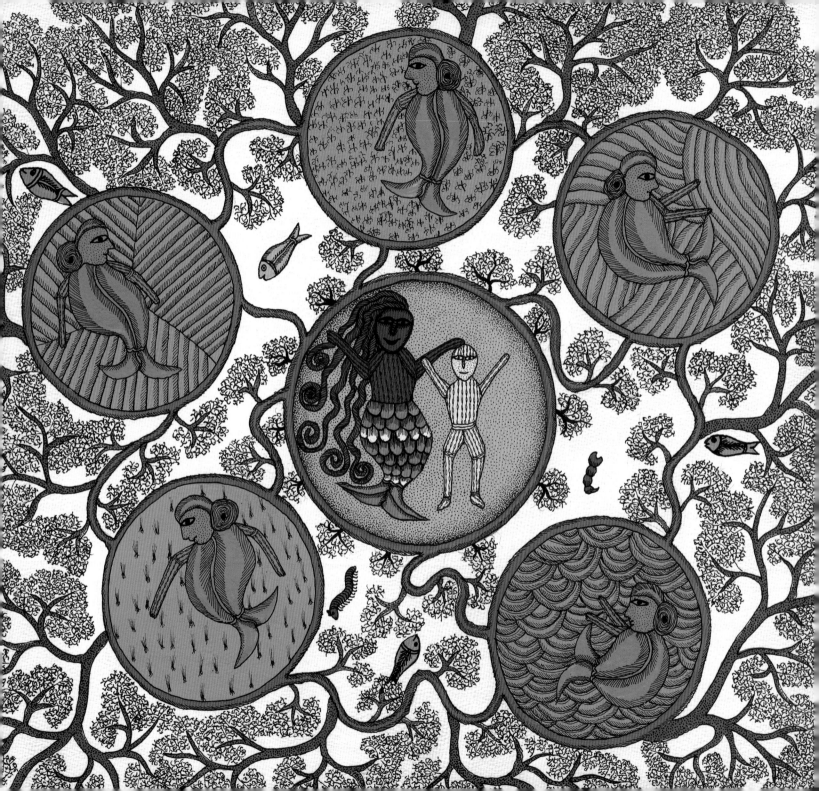

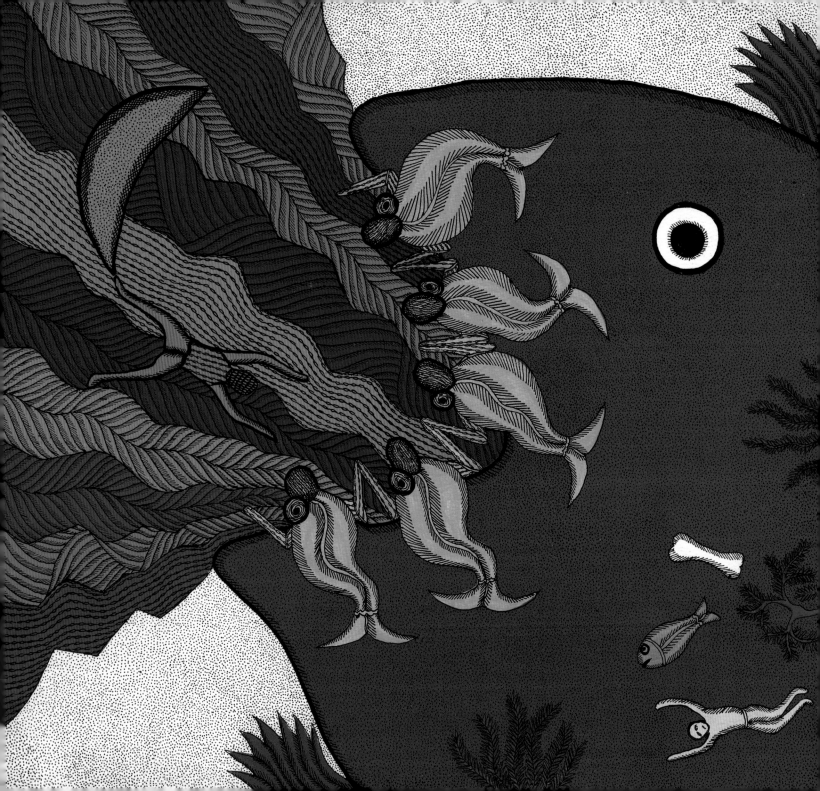

Her sisters were now allowed to go up and down as they pleased, and yet they preferred to stay at home at the bottom of the sea.

Only when there was a storm raging in the sky did the world above interest them. Then they swam up to the surface arm in arm, and sang to the sailors about how beautiful it was in their palace of coral, inviting them to visit. But the terrified men took their song to be the howling of the wind. And sadly, the only ones who did visit the sea bed were those that drowned. When this happened, the youngest mermaid wanted to weep, but as a mermaid has no tears, she suffered all the more.

At last the youngest mermaid turned eighteen. Her grandmother prepared her for her journey by decorating her tail with eight oysters. "That hurts!" she said, but her grandmother replied "You must bear some pain to be beautiful." And then the mermaid went up through the water like a bubble.

The sun was just setting as she rose up to the surface. She found herself beside a large ship, winking with lanterns and filled with the sound of music. Hiding in the swell of the waves, she drew nearer, wanting to be closer, but afraid to be seen.

On the deck, people danced around a handsome young prince. The mermaid watched, wishing she was among them.

And when the prince joined the dance, the whole ship cheered. Rockets and fireworks were set off, and it was as if a thousand suns were spinning in the darkness. At that moment, she was overcome by the powerful feeling that everything she had dreamt about had just come to life.

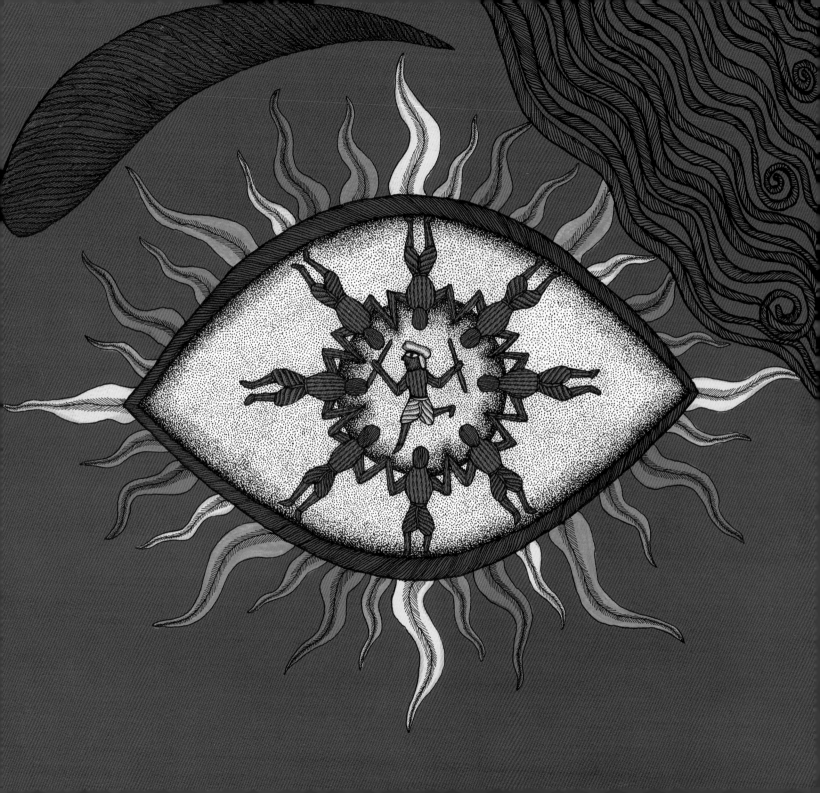

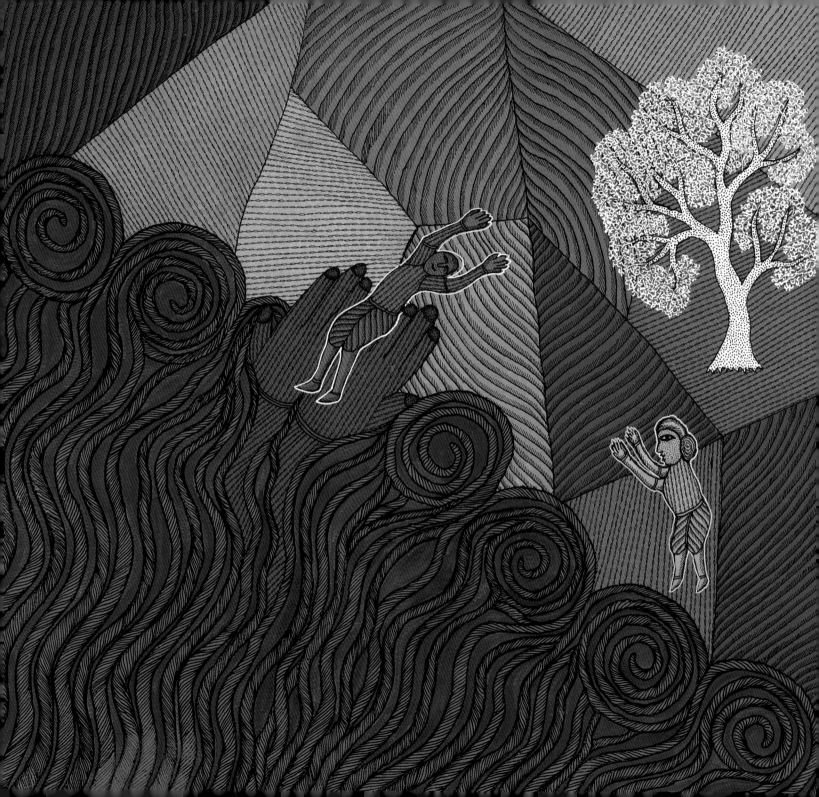

And as often happens at sea, everything changed in an instant. There was a great rumbling in the sky, and the waves grew wild and high around the ship. The mermaid did not mind this, it put her in a playful mood. But then she turned to look at the ship and saw that the waves had toppled it. The prince was in the sea with her! But her joy died quickly – she knew he could not live for long under the water.

Taking him in her arms, she held his head above the water, letting the waves herd her wherever they wanted. The prince was unconscious, and his clothes which had looked so fine when he danced, now weighed him down. As she carried him, she stroked his hair, thinking that he looked like a little like the statue in her garden. All night she swam, careful never to let his head sink below the water even when she tired.

When morning broke, the waves led them to shore. It was the mermaid's first sight of sunlit land, but all the sights she had waited years to see meant nothing to her now. What she wanted was for the prince to stir and look at her. How strange that she had kept him alive through the night, yet he knew nothing of her.

She swam along until she saw a palace on the shore, which she took to be the prince's home. But just as she had placed him carefully on the sands, a fisherwoman appeared nearby on the shore. Frightened, the mermaid slipped back into the waves.

When she returned home, the mermaid did not speak of her visit to the world above. Her sisters and her grandmother were surprised, for no one had wanted to go to the surface more than she. Now it seemed as if she carried a burden, and would do nothing but spend hours by the statue in her garden. Finally her grandmother coaxed the truth out of her: she had fallen in love with a human prince.

"Of all things!" said her grandmother. "You always were a strange one! Even if you love him as you say, will he love you? And where would you live? Consider, my dear, your beautiful fish tail – it's seen as ugly on land. Nothing can change that!"

The mermaid could think of no answers to any of this. But her grandmother's words stirred her awake. Now she knew what she had to do. And she looked at her tail as if it didn't belong to her.

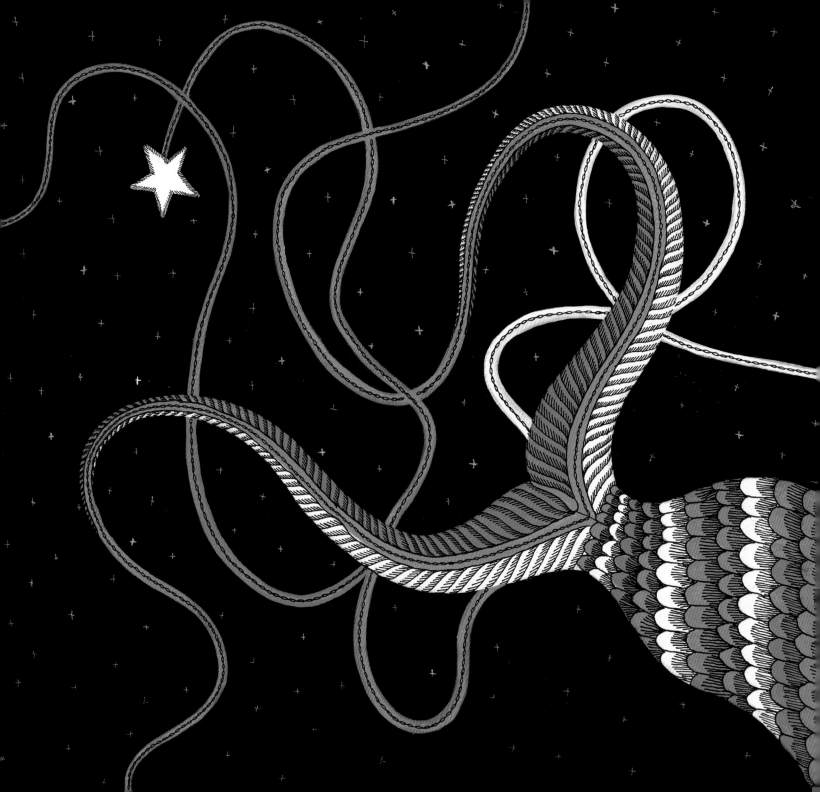

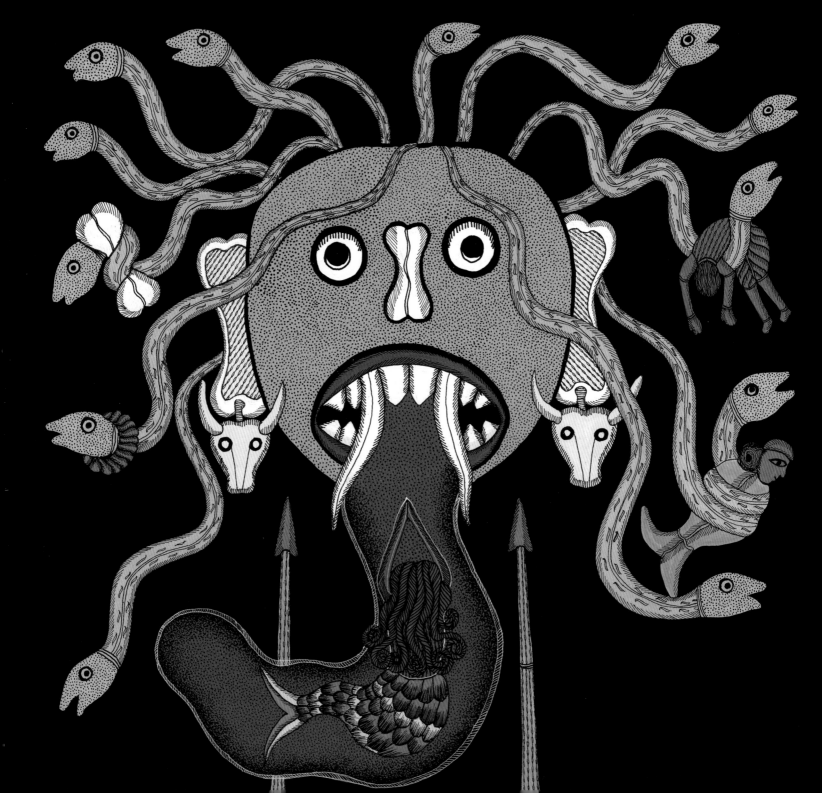

There was only one person who could help her: the dreaded Sea-witch. Her mind made up, the mermaid swam through the most frightful part of the sea, where whirlpools roared like mill wheels, and slimy arms reached out to snatch at anything that passed. She found the Sea-witch sitting outside her house, allowing a toad to eat out of her mouth.

"I know what you want," the Sea-witch said. "And it's very foolish of you. But yes, I have a potion that will divide your tail into legs. Mind you, every step you take will feel like you are walking on daggers, and once you cross this line you can never return to the ocean and your old life again. Are you still willing?"

The mermaid nodded, she had made up her mind.

"Not so quickly! If the prince marries someone else, your heart will break the next day, and you will be turned into the foam of the sea."

"I'm not afraid of that," said the mermaid.

"There's more! Don't forget my fee. What I want as payment is your sweet voice. Do you still say yes?"

If she had stopped to think, the mermaid might have been afraid, but she wanted this so badly that none of it mattered. So she spoke the last words she would say: "I will take the risk."

At that, the Sea-witch handed the mermaid a potion, and in exchange, took her tongue.

The mermaid could not find the strength to say goodbye to her family. Afraid to look back, she swam straight to the surface, potion in hand.

She made her way to the shore outside the prince's palace and there she drank the bottle all at once. The pain ran through her body like a sword, and the mermaid fell unconscious.

When she woke, she found the prince holding her hand. "Who are you? Were you in a shipwreck?" he asked.

"No, but I once saved you from one," she meant to say, but no words came from her mouth and she could only look at the prince helplessly. "No matter, you poor thing," he said. "Come, I'll take care of you."

It was only when she stood up that she noticed her tail had become a pair of legs.

With no water around her to take her weight, she felt heavy and unsteady. Each step cut like a dagger, but she gladly bore the pain to be walking next to the prince.

"What a strange and graceful walk you have!" he said. "I'm sure everyone who sees you will love you."

And sure enough, the mermaid was welcomed in the palace. People marveled at her, charmed by her difference, and the prince grew very fond of her. He called her his dear little foundling and took her riding and dancing and was delighted when she looked happy.

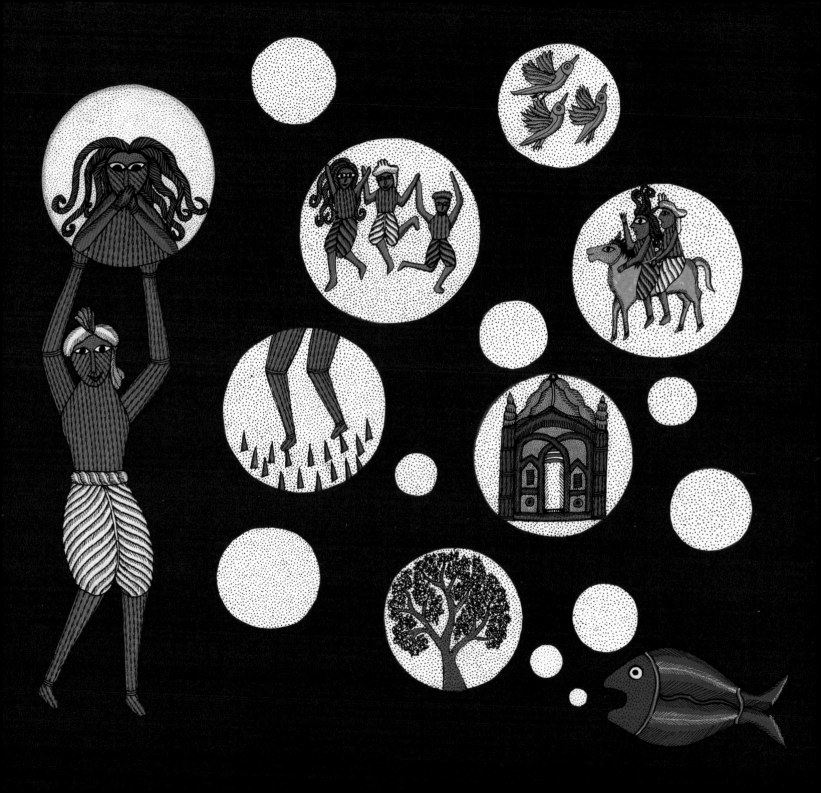

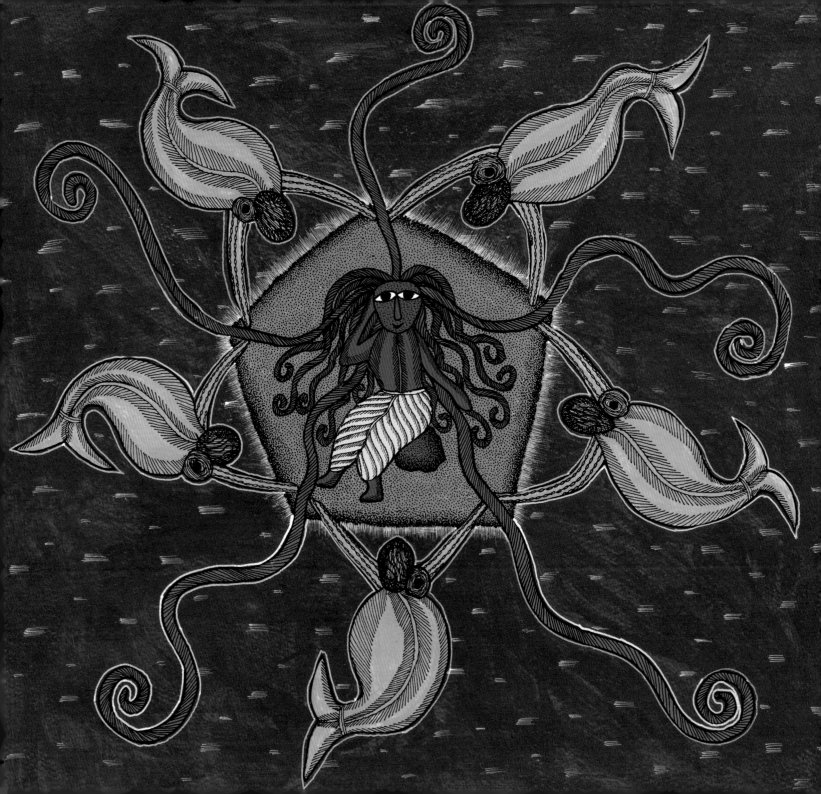

Every day seemed to bring something new and there were many things the mermaid enjoyed.

"How curious you are!" the prince said. "You make even ordinary things seem special. Be near me always." And he gave her velvet cushions so that she could sleep outside his door.

But sleep did not come easily. When the excitement of the day had died, and the palace slept, the mermaid grew restless. She found herself going down to the shore to cool her burning feet in the waters. Then her mind went over the happenings of the day, and to her loved ones and her old life in the sea. But she had known the path would not be easy, she told herself, she had to be patient.

One stormy night she saw her sisters on the waves, singing arm in arm. They rushed over to her and said the Sea-witch had told them what she had done. "You were always different from us, and now, all the more! But are you happy?" they asked, and then wept because she could not reply.

Months passed and the prince loved the mermaid as one would a pet, but he never thought of marrying her. It pained the mermaid that he did not feel the same kind of love she felt for him. And with foreboding, she remembered the Sea-witch's warning that if he married someone else, she would turn into sea foam the next day.

"Don't you love me most of all?" she would try to ask him with her eyes.

"You are most dear to me, my poor mute one," the prince would say, seeing her look. "Strange, but you remind me of a woman who saved my life once. I was near to drowning and I recollect her face as if in a faraway dream, but she is the only one I could marry. But until then I have you to remind me of her. Never leave my side!"

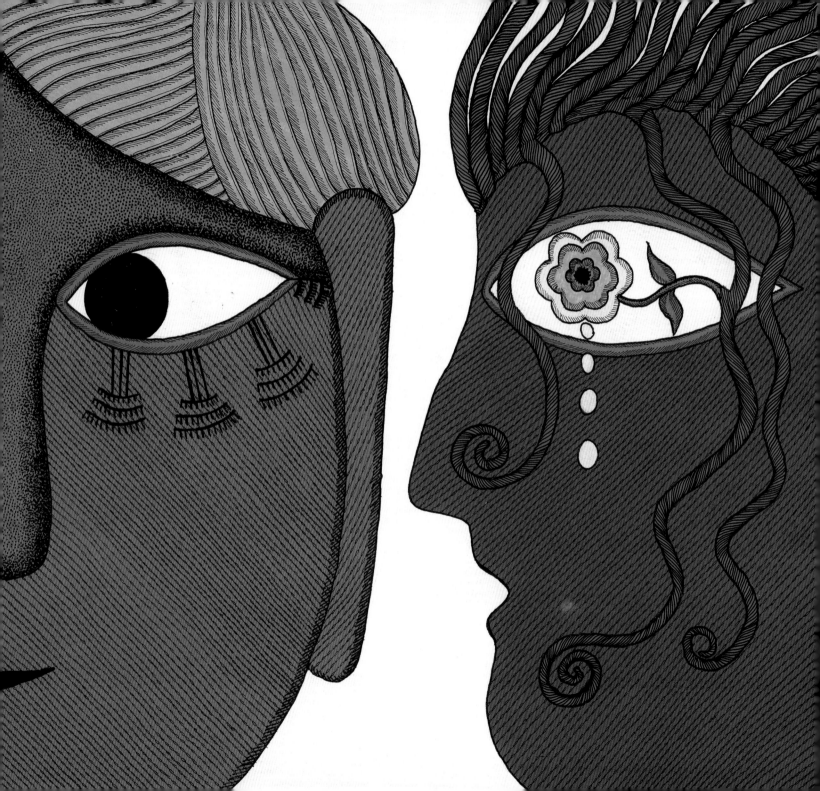

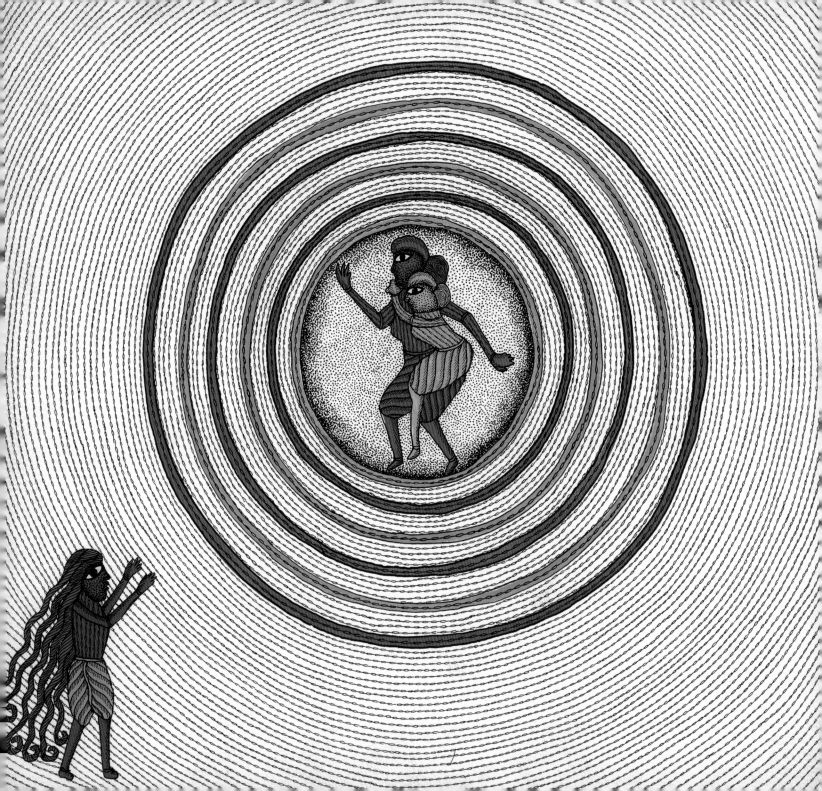

Then one day the thing the mermaid had dreaded all along happened. A bride was found for the prince – the princess of a nearby kingdom. "My heart is set on the woman who rescued me," he said. "But since she is nowhere to be found, I will meet this princess. Be by my side!" And much as she did not wish to go, the mermaid could not find a way out of it.

They all boarded a grand ship, and the prince led the mermaid aboard saying "I hope you are not afraid of the sea, since I found you almost drowning on the rocks." And on the journey, he told her stories of storms and strange creatures at the bottom of the sea, and she smiled, for no one knew better of all those things than she.

They were received with breathtaking pomp at the palace, and when the princess appeared the mermaid gasped. The princess looked very much like her, and she had a beautiful voice – almost as beautiful as the one the mermaid had given to the Sea-witch.

The moment he saw the princess, the prince ran and picked her up in his arms crying "You! You are the one in my dreams! I never thought to find you, but here you are. Let us be married at once!"

"I am happier than ever before," he said, turning to the mermaid, "and I know you share my joy for you love me more than anyone does."

The mermaid felt her heart beginning to break while around her, the kingdom erupted with joy at the wedding.

That same evening the bride and bridegroom with their retinue boarded the ship back to the prince's kingdom. At night the mermaid strode the deck counting the hours until sunrise. The Sea-witch had spelled her fate – this was her journey's end.

"So this is where my course has led me," she thought. "To change myself and bear every pain and get nothing in return!" And for the first time, she felt a great anger inside her.

Then suddenly, swimming along the dark hull of the ship were her sisters, faces grim, and heads shorn.

"We gave our hair to the Sea-witch," they said, "in exchange for a magic knife. Plunge it in the prince's heart before sunrise, and bathe your legs with his blood. You will have your fish tail back and return to us. Hurry! The sun is about to rise."

Passing her the knife, they sank back into the depths of the sea.

The mermaid looked out at the lightening sky and at the sharp knife in her hand. Her anger flowed through it as she thought of the prince in his chamber, his heart full of his new bride. With one strike she could have her revenge, and get her old life back.

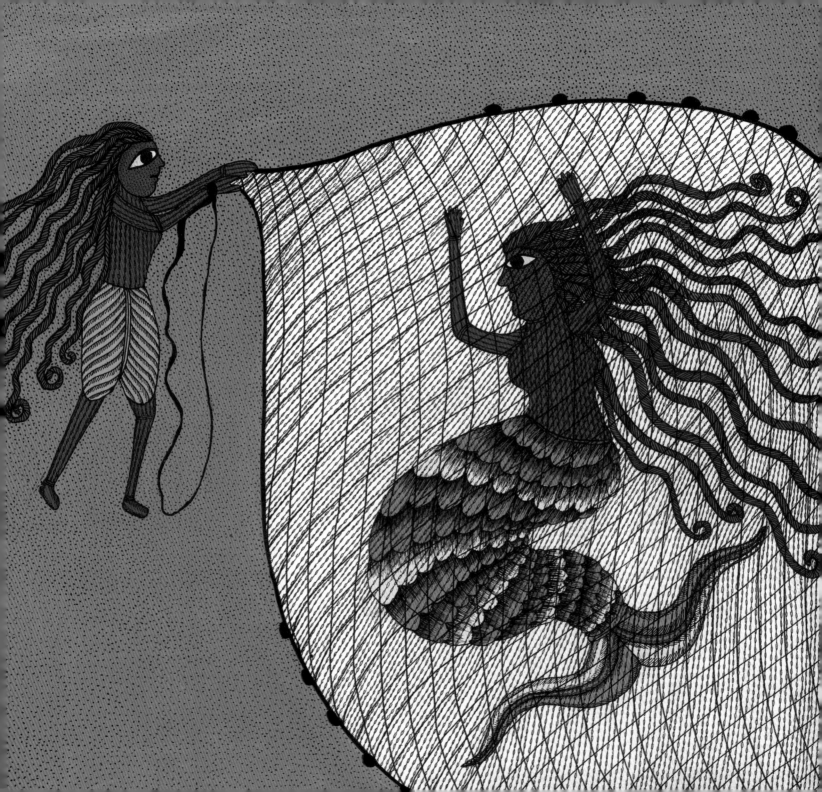

The mermaid crept across the deck towards the window of the prince's chamber. As she peered through at the sleeping couple inside, she caught sight of her reflection, and stopped, knife in hand. She could not recognize herself. Through all the transformations and all the changes she had willed on herself and suffered, she had never been afraid. Now she was frightened of what she was about to become.

Slowly, the truth came over her – her plight had nothing to do with the prince at all. He had only been kind to her in the way he knew, but he only knew his way, nothing more. He knew nothing of her, and could not carry the weight of her dreams. The trap she was in was of her own making.

And if she were to kill him and return to her old life, she would harm herself more for she could not bear to kill something she had loved. There was no way back now. Would it not be better to live as the foam of the sea, being passed between the waves and the land, than to return in her old form, diminished after all her travels?

And so, with relief, she flung the knife away from herself, into the water.

And now a strange thing happened. When the magic knife touched the waves, there was a bubbling in the sea, and instead of turning into foam, the mermaid found herself lifted into the air. She was surrounded by a cloud of beings so fine that she could see through them. They had sweet voices, but no human could hear them, just as no human eye could see them.

"Who are you?" she asked, and found that her voice had returned.

"We are the daughters of the air," they answered. "And now you are one of us."

The mermaid was delighted. "I was born into water," she said to them. "And I know the world on the shore too. Only the air is left to explore, and it seems to hold more freedom than sea or land. There could be no better reward for one such as me."

And so she flew up to join the ever-moving, ever-changing clouds that sail high above.